When I Were a Lad...

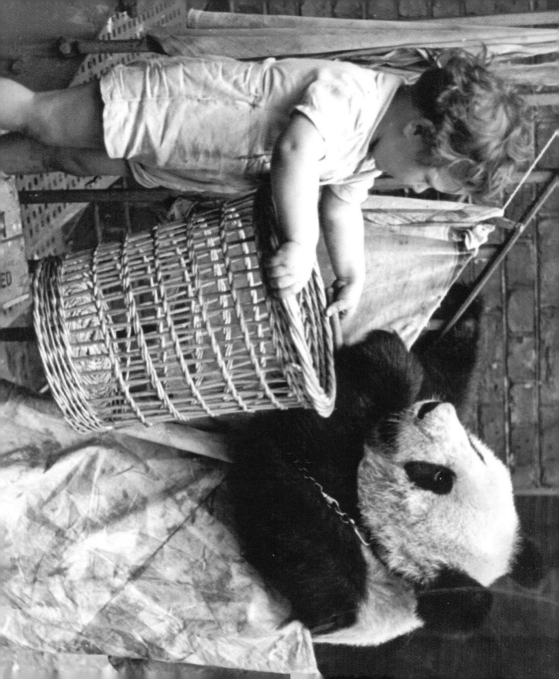

When I Were a Lad...

Snapshots from a time that Health and Safety forgot

Andrew Davies

PORTICO

First published in the United Kingdom in 2010 by
Portico
43 Great Ormond Street
London
WC1N 3HZ

An imprint of Pavilion Books Company Ltd

© Pavilion Books 2009, 2010

ISBN 13: 978-1-907554-00-1

Cover images: Corbis

A CIP catalogue record for this book is available from
the British Library.

19 18 17 16 15 14

Reproduction by Rival Colour, Ltd
Printed and bound by GPS Group, Slovenia

This book can be ordered direct from the publisher at
www.pavilionbooks.com

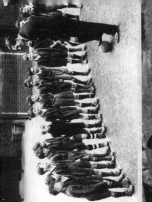
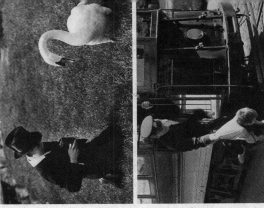

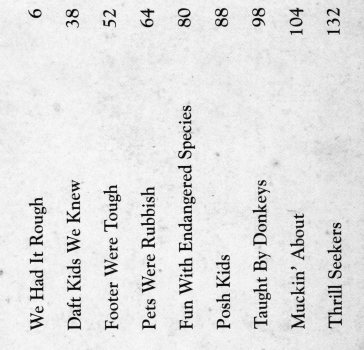

Contents

We Had It Rough...

When I were a lad, it weren't all beer and skittles.

In fact, it were neither beer nor skittles.

If somebody gave you an apple you had to work

out where maggot hole was.

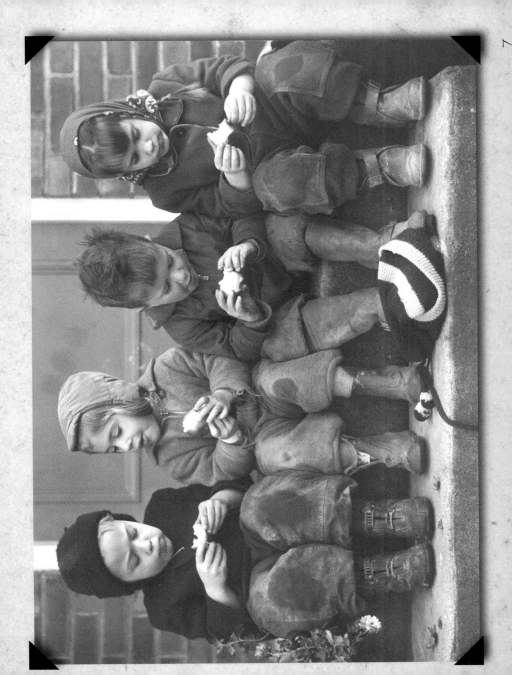

...sometimes you had to eat what you could find.

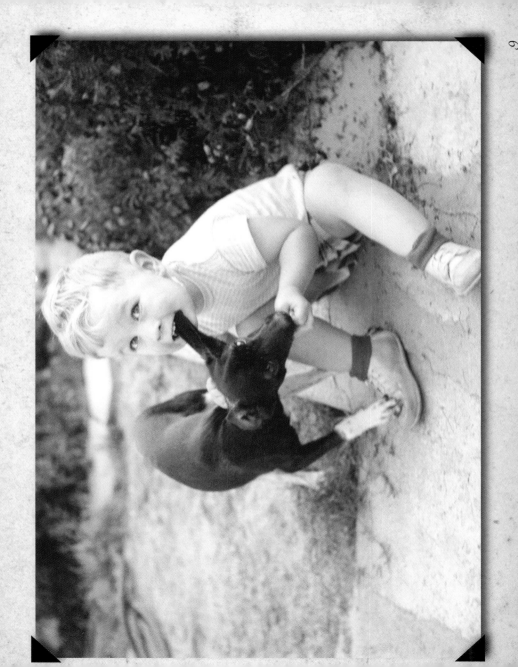

Kids didn't have it easy. Swimming lessons? If you couldn't swim after two lengths of pier with Uncle Stan, then they chucked you over the weir and said, "get on with it".

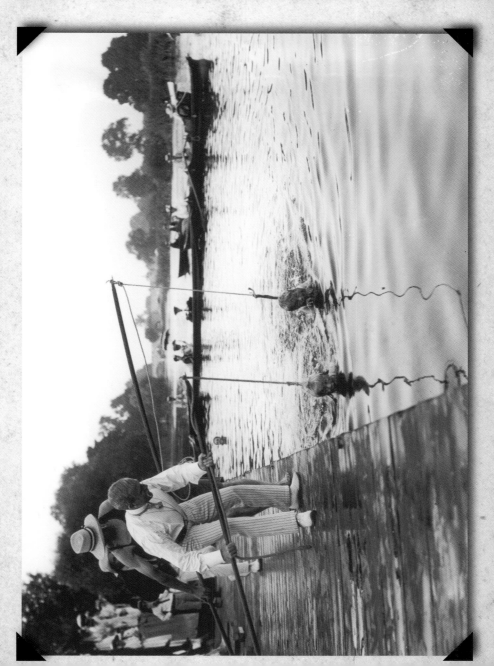

In them days, the police didn't stop you from fighting. No, they actually rounded you up and made you fight.

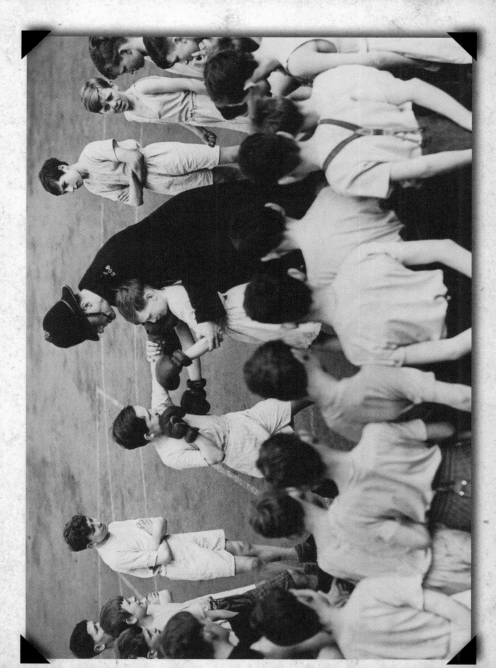

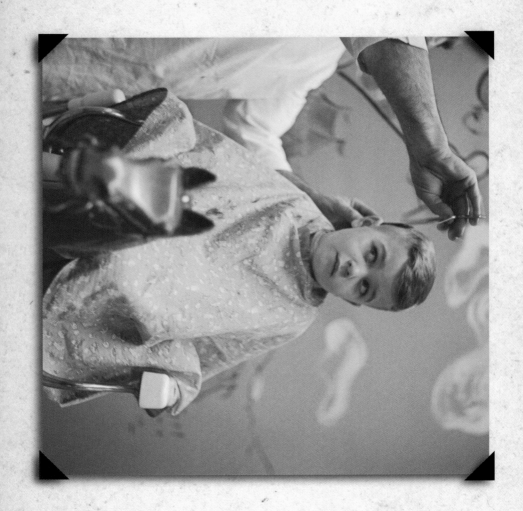

There were only one kind of haircut - the medium trim. If you didn't like it, tough.

We made our own entertainment back then.
Swinging round lampposts were brilliant fun.
You didn't need rubberised purple tarmac

to land on.

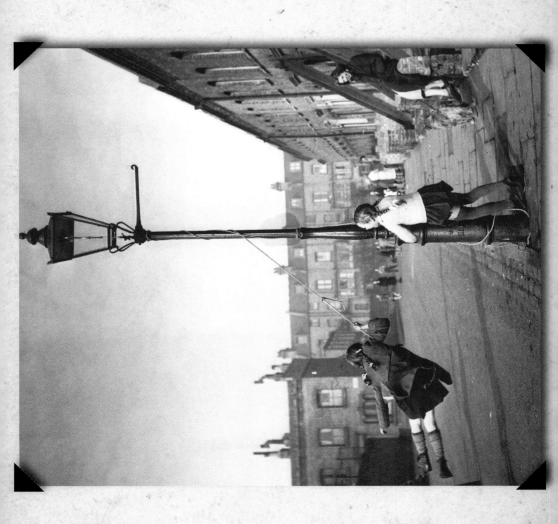

it were all free, too. You could bowl marbles, play hopscotch or chuck stones at trams and it cost you nowt. Our sister were hopscotch champion of our road for three years running.

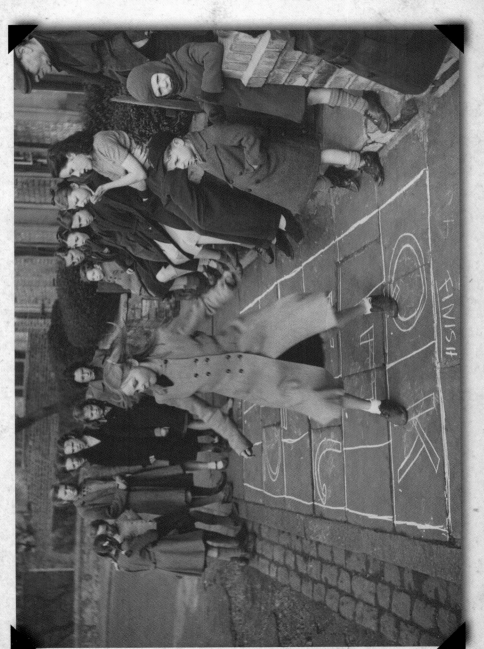

There were no such thing as kids' fashion.
You wore what yer nan knitted for you...
and liked it.

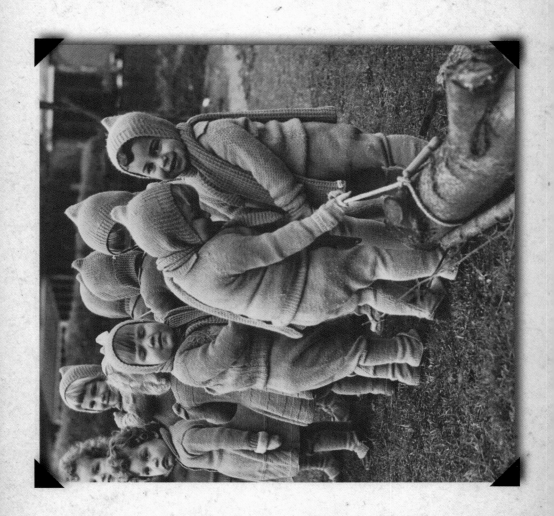

We had proper caps back then. None of yer Nike, Reebok, Adidas, baseball rubbish. It were solid tweed and you could use it as coal scuttle.

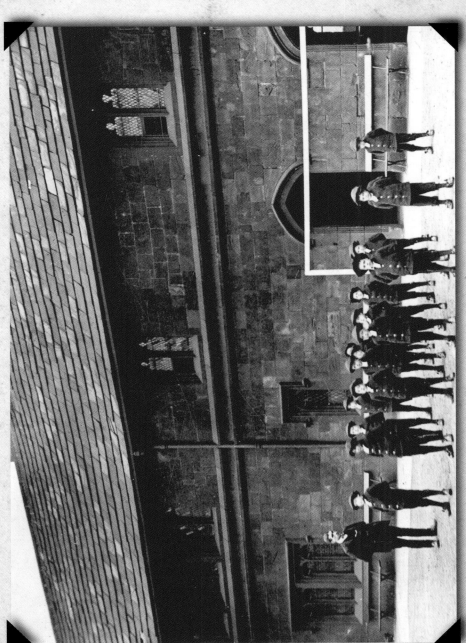

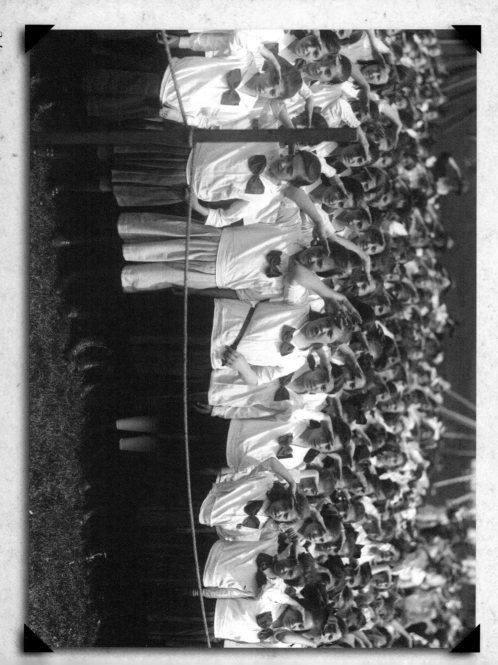

Some kids had to go to school looking like big jessies, but they just put up with it. Nowadays they'd be all over papers saying their human rights had been contravened.

Getting to school weren't easy,
either. It were often gridlocked at
bottom of our road.

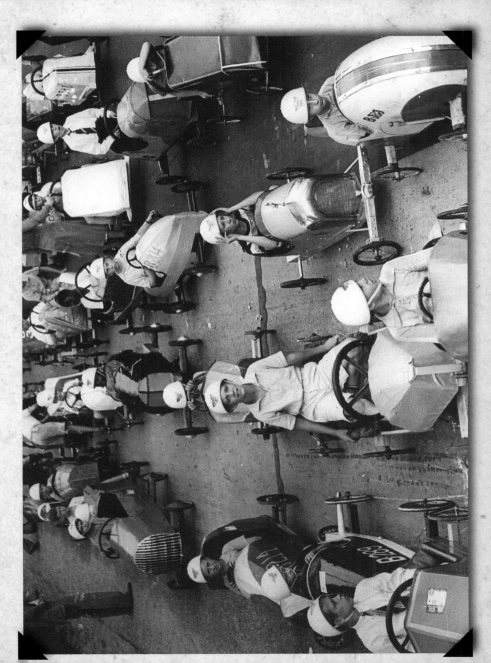

...and sometimes you'd get to school and find they'd moved it.

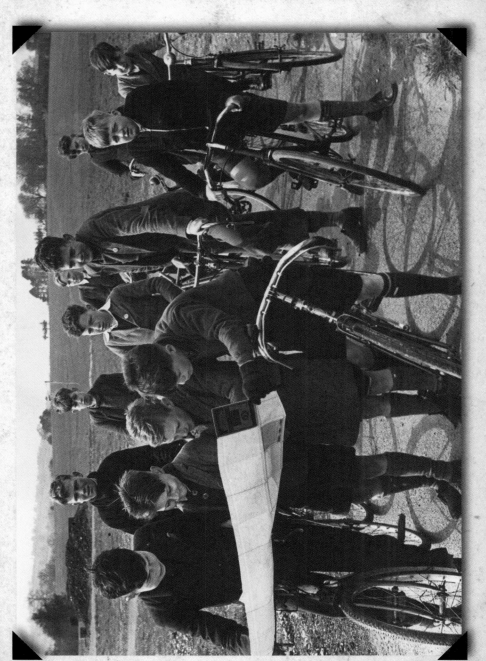

29

When I were a lad they hadn't invented "waterboarding". The only unnecessary form of torture were the school band.

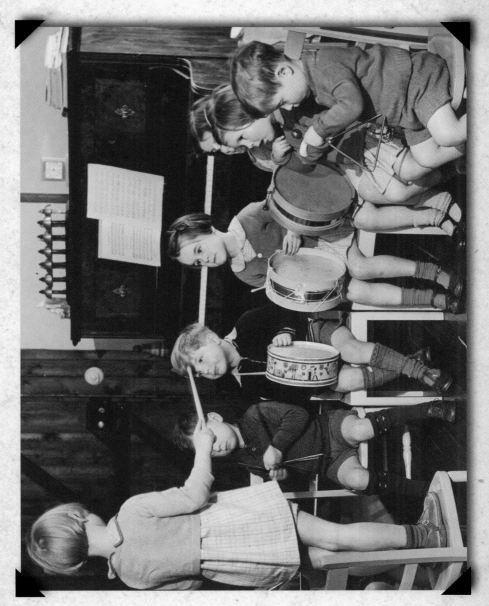

When Mrs Olllerenshawe took us on a tour of the Dales we had a great time...until she started doing handbrake turns.

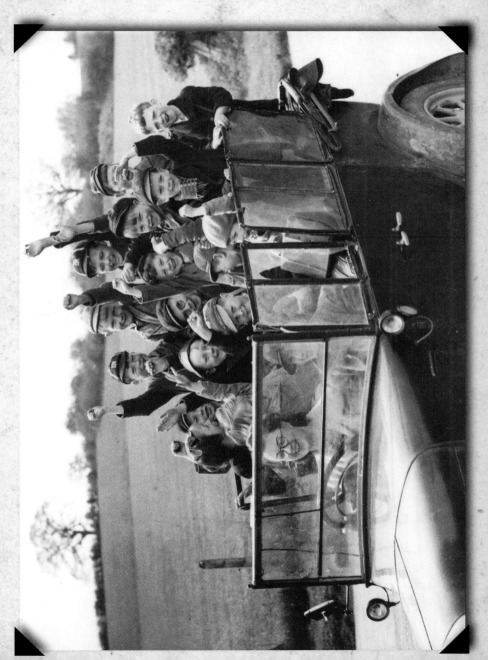

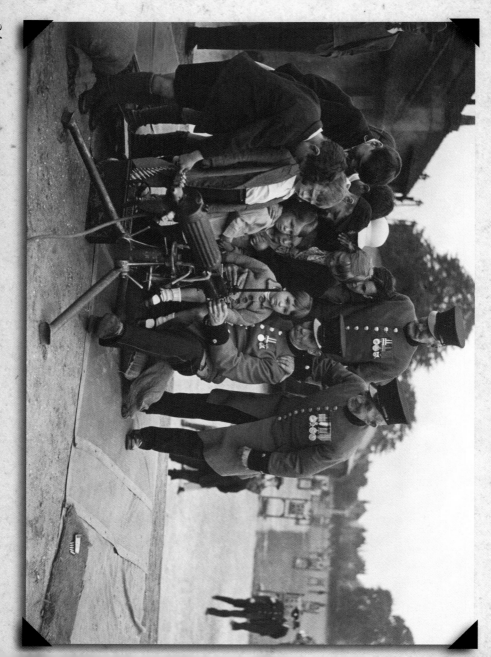

In them days we got things in
proportion. We didn't get upset when Grandad
told us how he'd machine-gunned a whole
platoon of Jerries to death... We just wanted
him to clean his teeth more often.

They say you swallow a gallon of dirt before you die. Well, we'd find that much down our trousers after playing in street. And it never did us any harm.

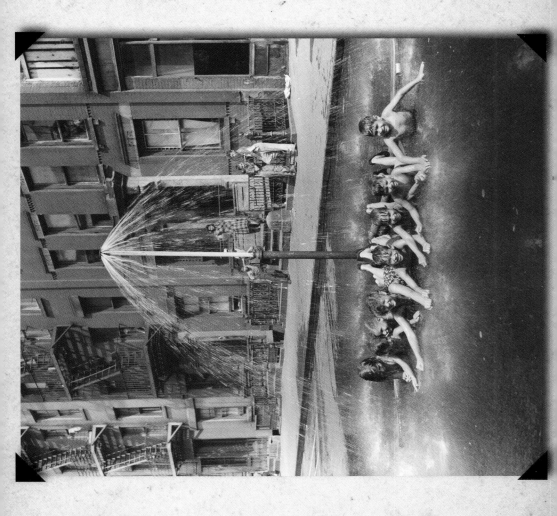

Daft Kids We Knew...

Today you'd see 'em on 'Britain's Got Talent', but
in our day they were known as the daft kids.
The showoffs who nobody wanted to sit next to...
unless they had sweets.

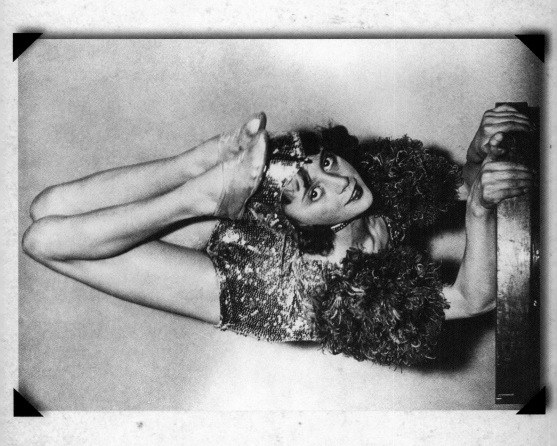

the highlight of their year was the school photo.

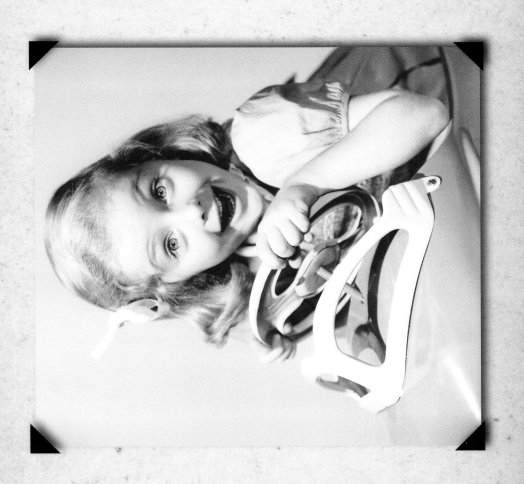

42

They thought they were so clever, showing off the latest toys.

43

Or dressing up for history lessons.

Colin the Gladiator always wanted us to do

Romans so he could wrestle a lion in class.

When it finally came round he were off with

measles and chronic nits.

45

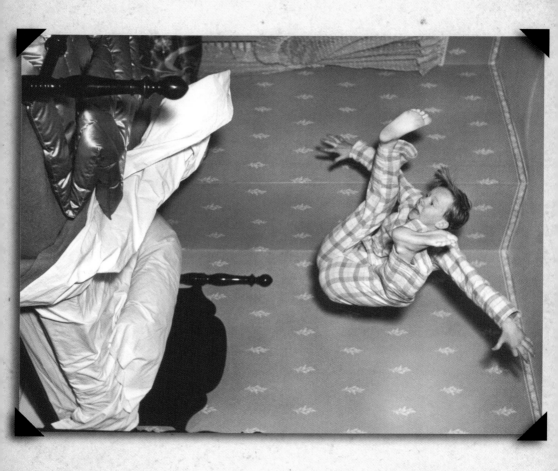

Now, respect where respect is due. As a kid the ability to produce vast reserves of natural gas is a virtue. But sometimes you can go too far...

Some kids loved dressing up as policemen.
Nobody'd play with them, so they
had to use stuffed pets instead.

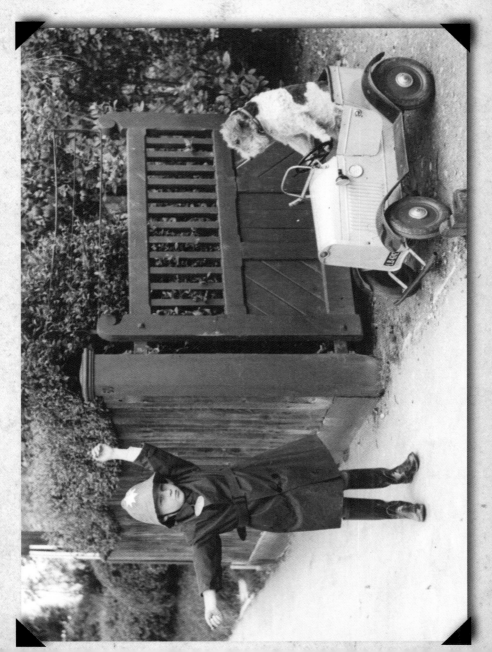

And some loved dressing up full stop.
That Elton were always popping round
in his latest outfit.

Footer Were Tough

In our day, footer boots were made for clogging, not dribbling. The aim was to give ball a right good clog. And the golden rule was the shortest lad had to be goalkeeper.

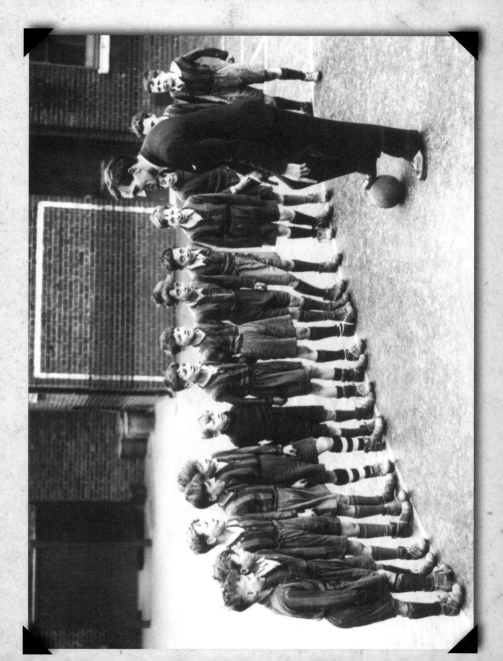

Footballs were made of premium rhino hide. Soaked in water they could take masonry off a bank building. You tried to head it but hoped you didn't.

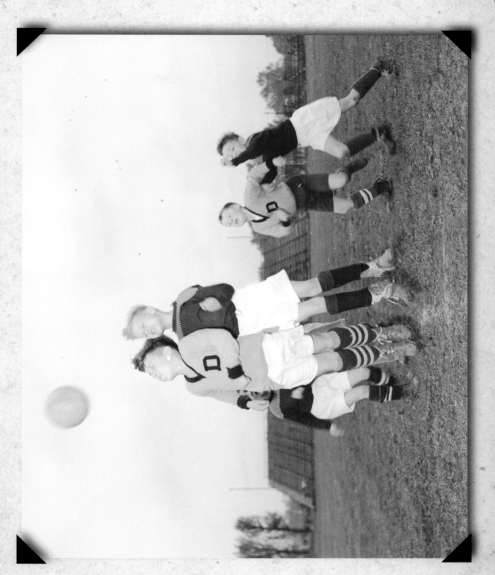

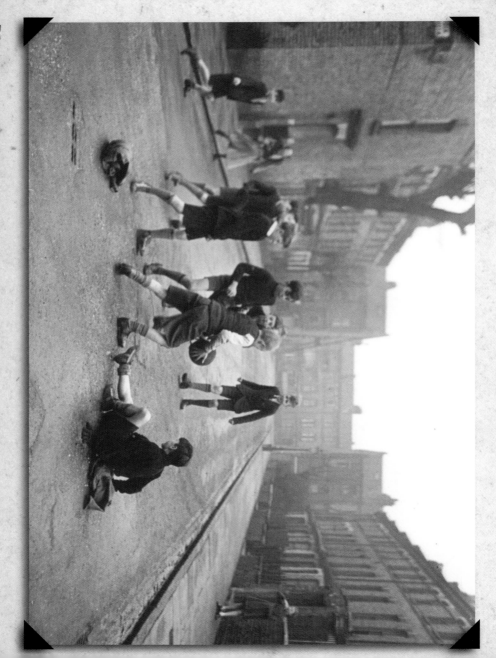

We played every night in our street and our mum used to join in. She were a kind of Norman Hunter/Ron Harris figure in central midfield. She were tough but fair and never bit anybody's ear clean off.

Youngsters today think they invented footer, but we were well ahead of them. Mr Timms taught us shooting, Mr Arkwright taught us clogging and Mrs Heptinstall taught us the biodynamics of the long throw.

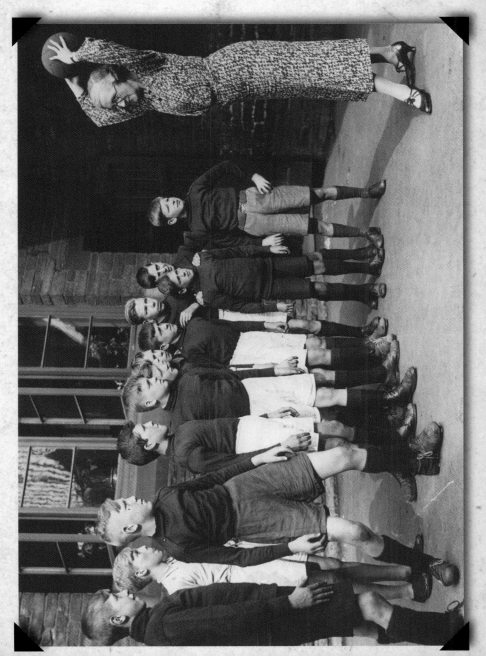

If you supported a big team like Barnsley it only cost two shillings and sixpence for the official team kit... Or your nan could knit it for you. Try getting your nan to knit the Manchester United away kit these days.

It'd give her arthritis.

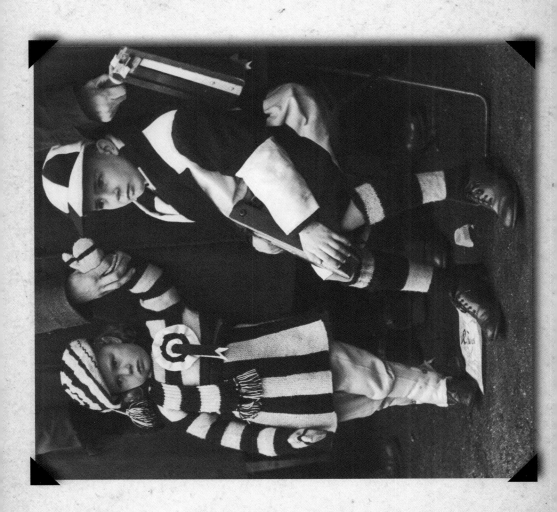

There were no need to get to the match early. You could stand at back of Barnsley home game and say, "can I go down front, Mister?"

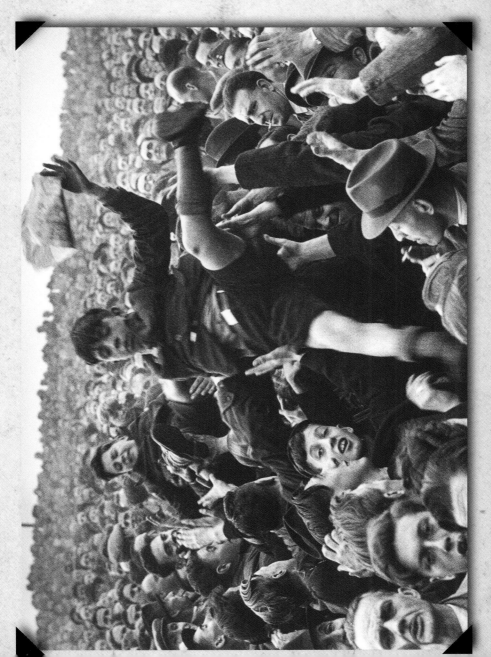

Pets Were Rubbish

After second world war there were international shortage of pets. Most of 'em were eaten. We had to make do with a pet chicken for three years. Mind you, it did this brilliant trick with a hoop...

65

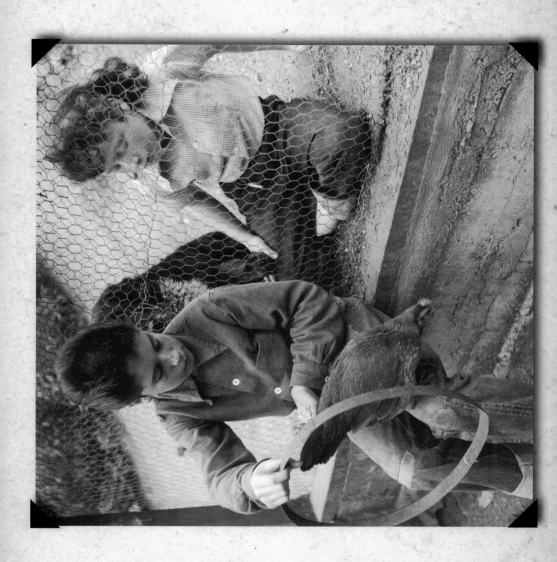

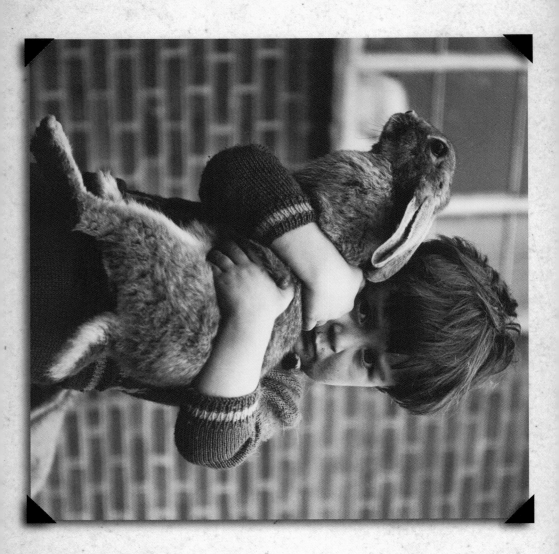

If you found a pet, you had to hold onto it f' dear life.

There were such a shortage, posh kids were forced to have working-class pets.

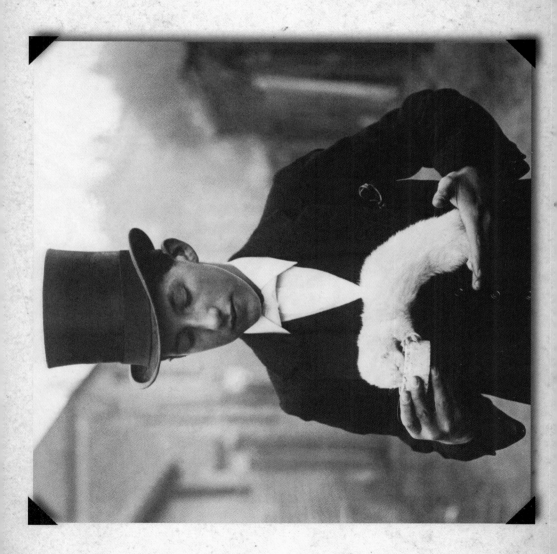

...and any old manky cat would do. Even evil-looking ones that could read your thoughts.

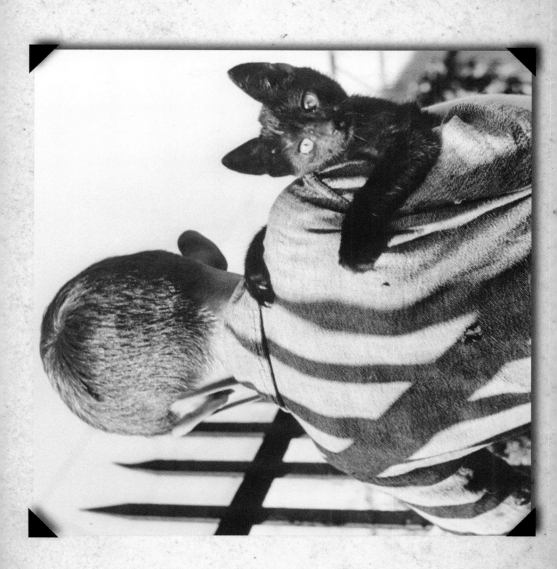

Me dad brought home an "Abyssinian Terrier" for our sis. She were well chuffed...

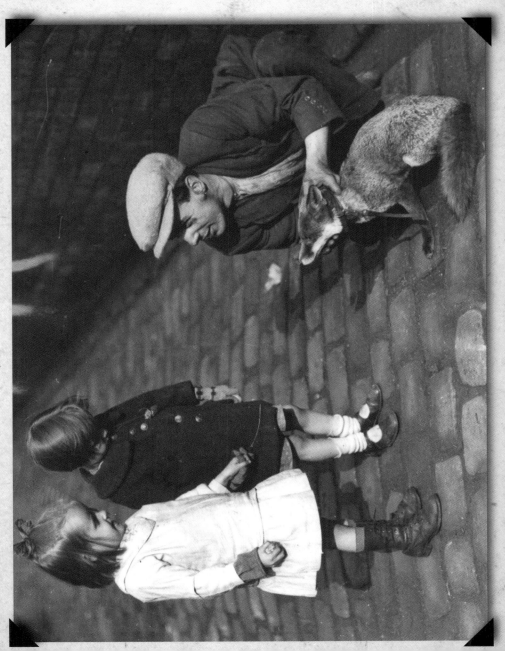

...till everyone at school told her it were fox.

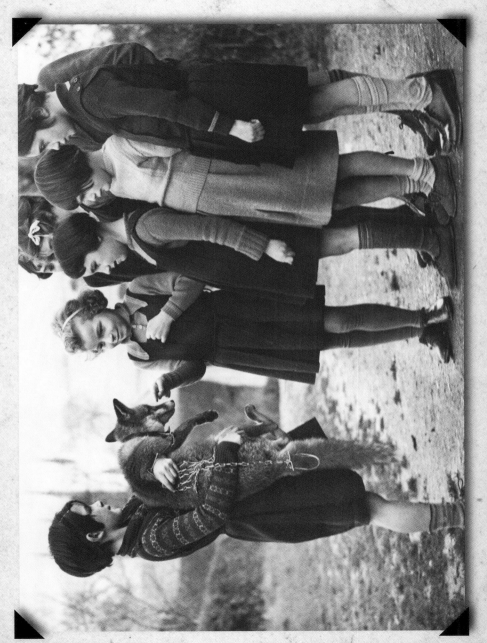

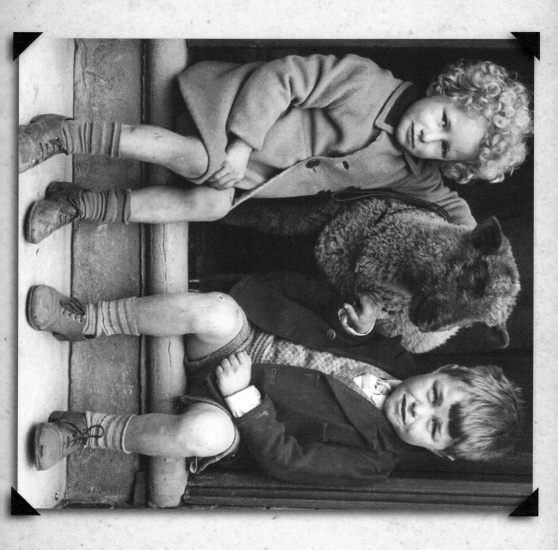

Stan and Arthur reckoned they had sheepdog.

But it were sheep.

The thing that made us really mad back then were the pet touts.
Yeah, you could have a cat... if you had the brass.

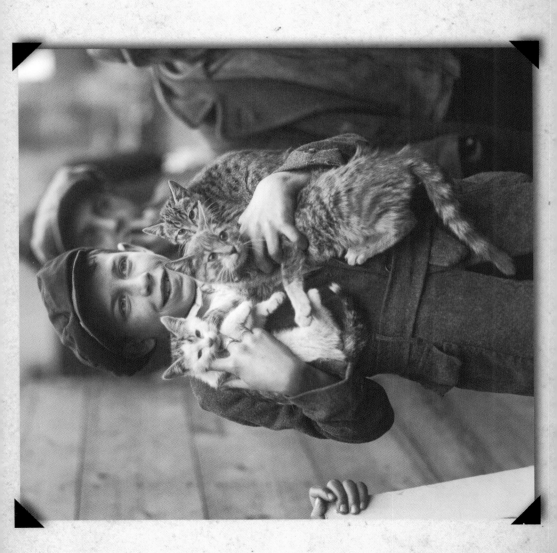

Fun With
Endangered Species

You didn't have to worry about animal civil rights. If you wanted to have a panda take your picture, then it were fine.

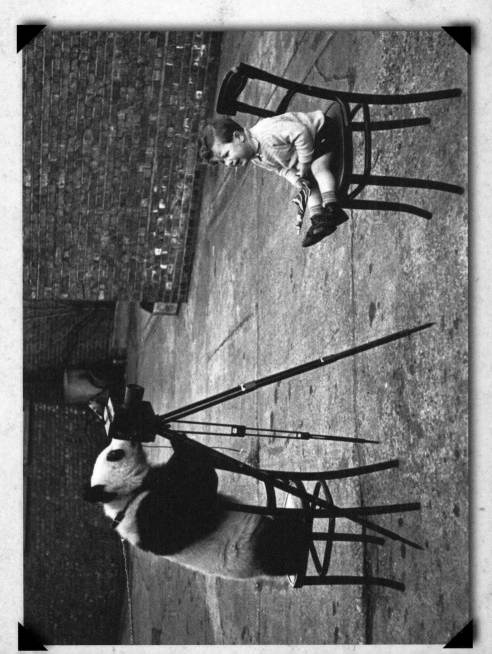

...and if you were short of a goalie, y'didn't have to call the World Wildlife Fund to check if it were okay...

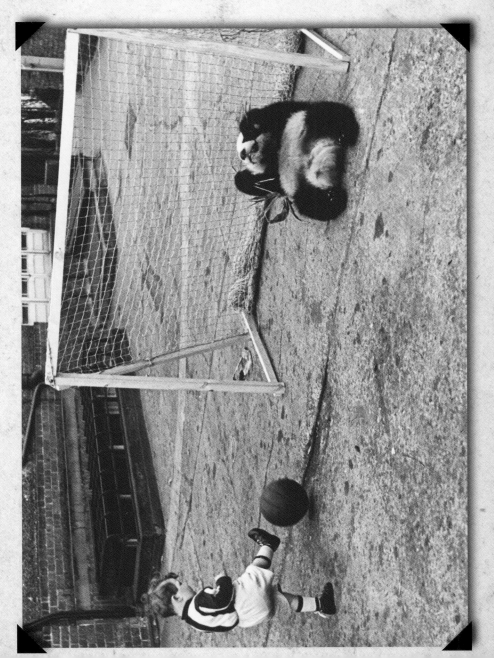

...or ask them if he could help with washing.

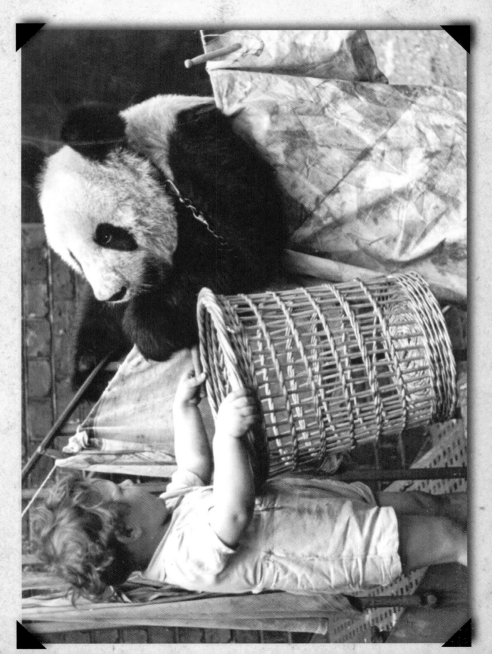

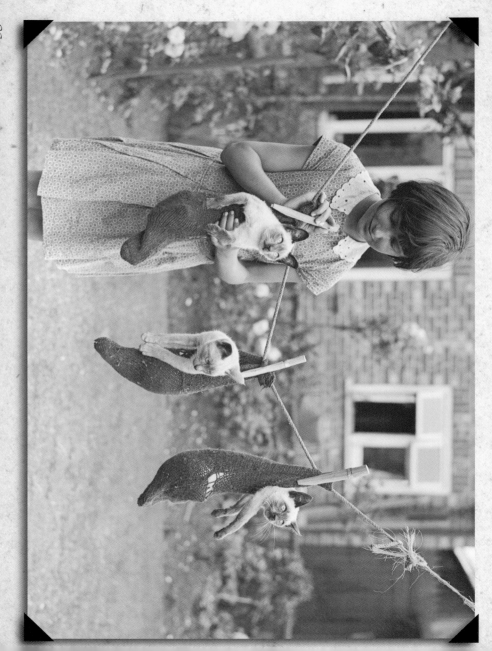

You could endanger your own species.
If you ran out of air rifle targets, next door's
kittens would do. Paper targets with bullseyes
were okay, but they never went "Miaoow!"
when you hit 'em.

Posh Kids

Mind you, if there were ever a better target for air rifle, it were horse's rump when waggoner took posh kids back to station at end of term.

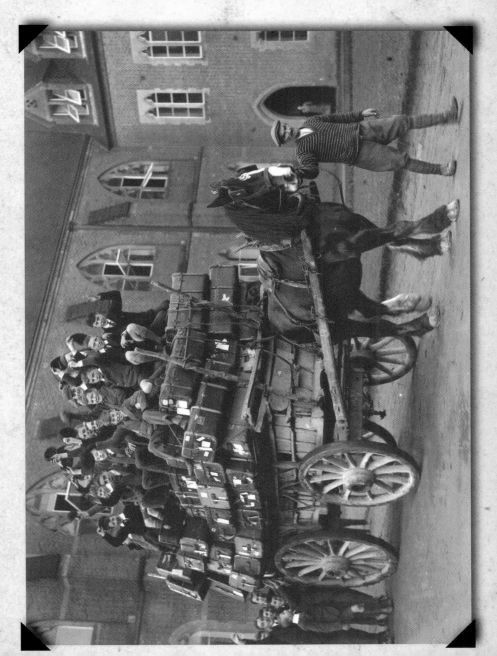

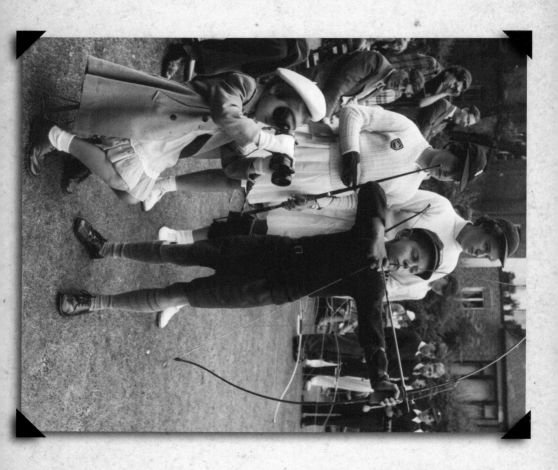

These days you can't tell posh kids from common ones. When I were a lad, posh kids had no idea how to dress.

...or when a swan was about to break their arm.

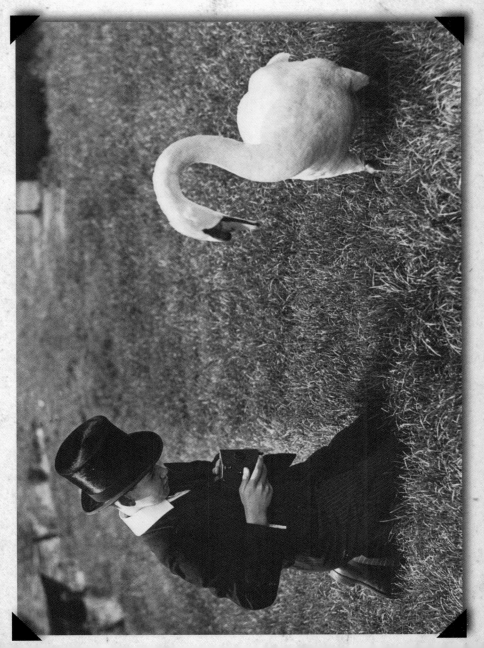

Posh kids did different stuff to us. They had ponies and drinking competitions.

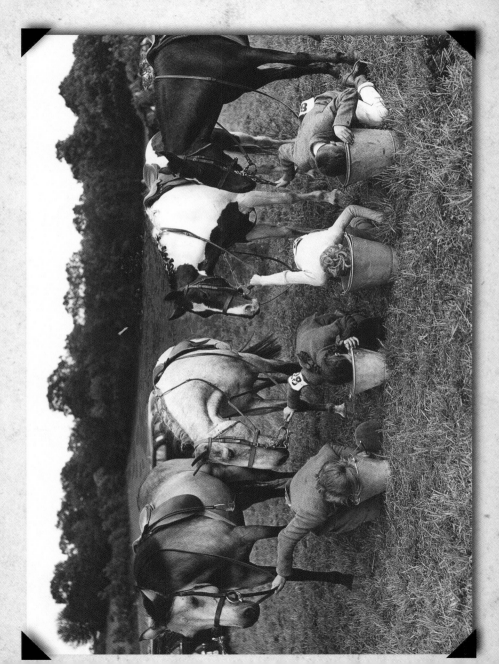

they didn't have toy cars, no, they had "scale models". When we made a model car it looked like a piece of 4 by 2 on wheels.

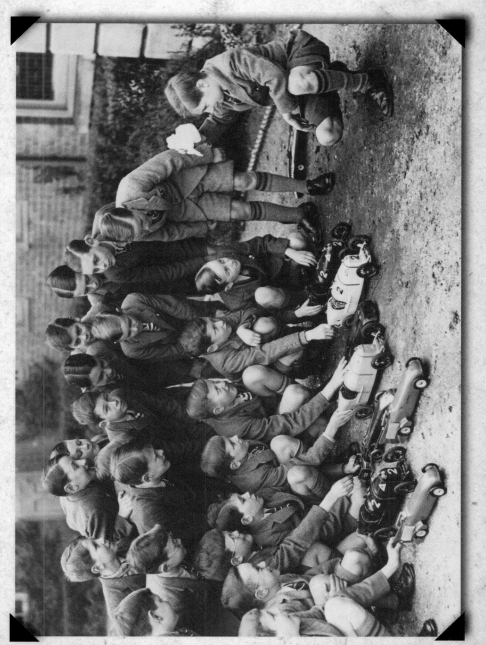

Taught By Donkeys

In our day there were no such thing as supply teachers. If school were short they'd get donkeys in.

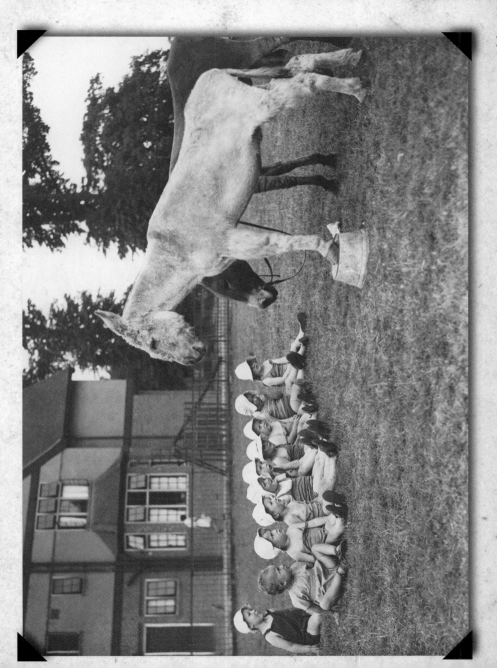

If you were lucky, you got one-to-one tuition.

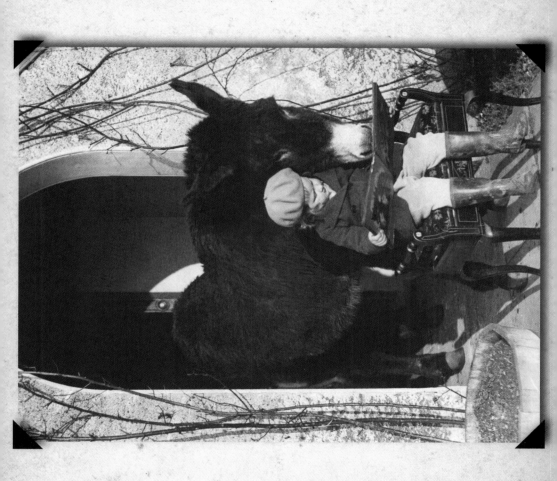

...and some had to make do with horses.

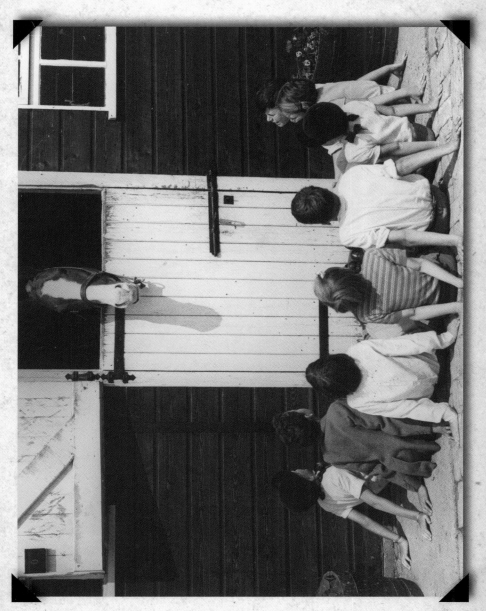

Muckin' About

In them days, folk let you get on with stuff.
If you wanted to fall off the edge of Empire State
Building while playing the Milky Bar Kid, that
were fine.

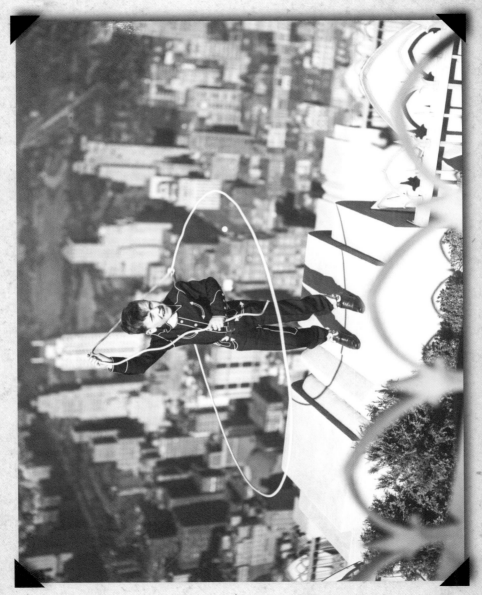

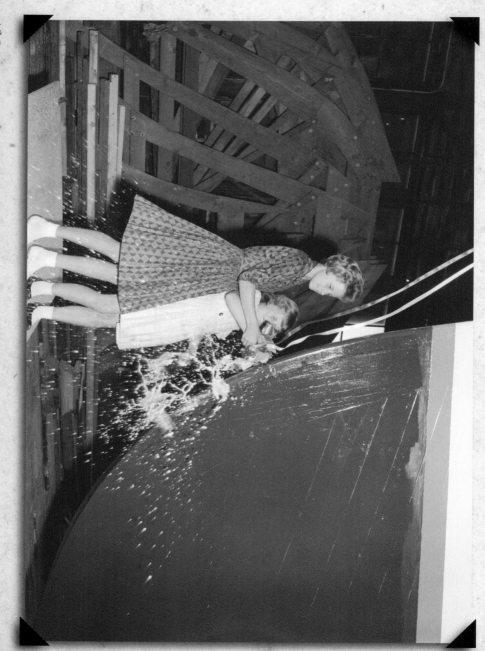

Protective goggles, protective gloves.
What were they all about?

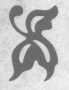

Nobody had seen the film 'Don't Look Now'.

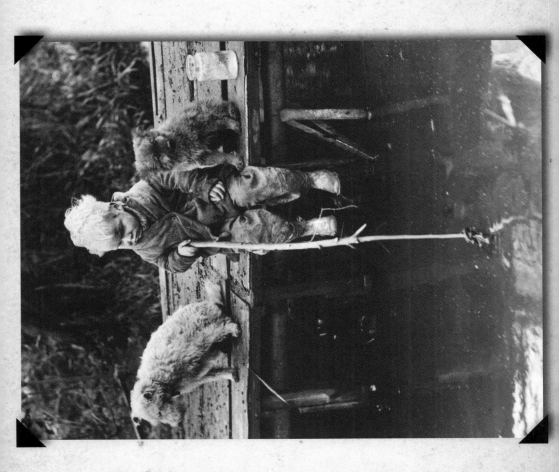

We hardly ever came back from trips to the zoo with all our classmates...

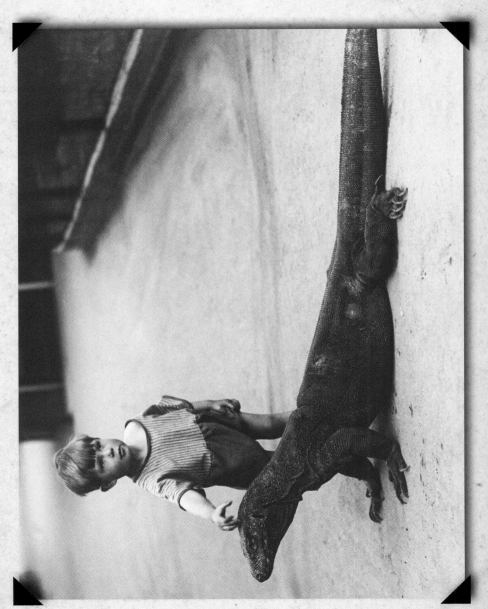

there were none of your fancy Alton Towers thrill rides, neither. For a farthing you could get conductor to swing you round back of tram by your jumper for half a mile...

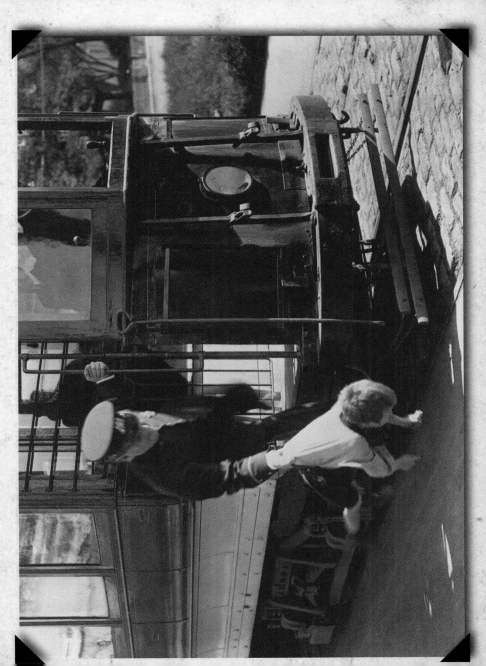

We didn't have 'Nemesis Revenge', we had not-letting-go-of-the-kite.

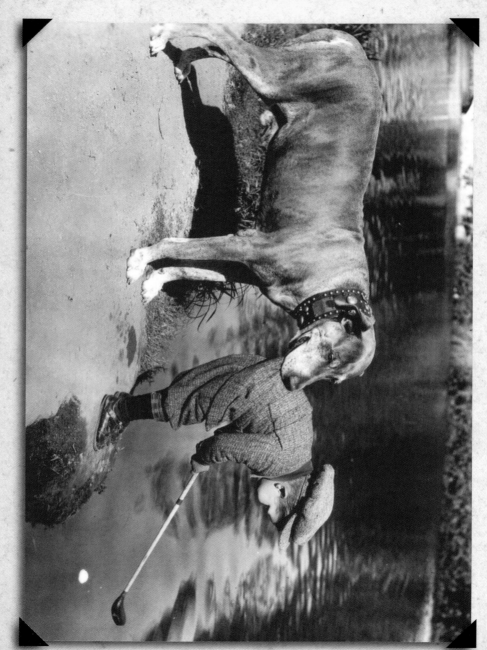

Crazy golf really were crazy.

And if it were stormy, we'd be straight off to Filey or Scarborough to see if we could get rid of Cousin Eric.

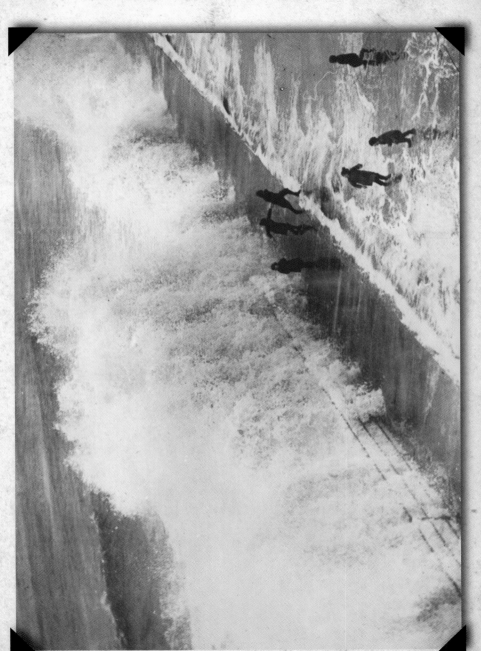

Frankly, I'm amazed we won the war, our mines were rubbish. You could jump on 'em all afternoon and not even a "tick-tick-tick".

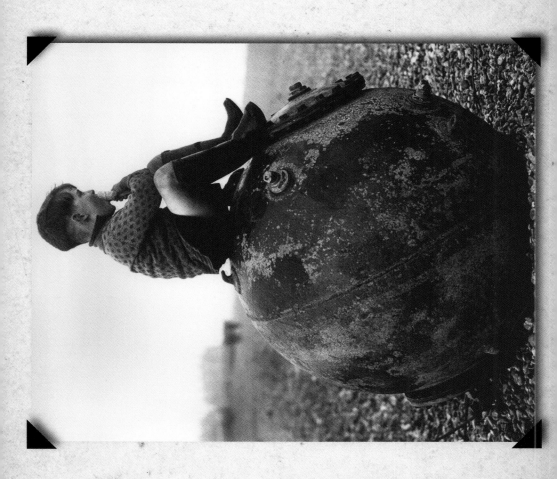

In them days, the swotty kids loved to go home and fiddle with their radioactive isotopes.

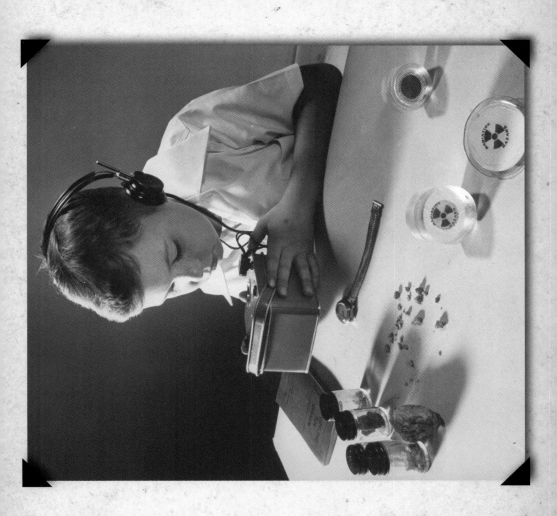

124

While the street kids played five-card rummy for big cash prizes. Sometimes four pence ha'penny would change hands of an evening.

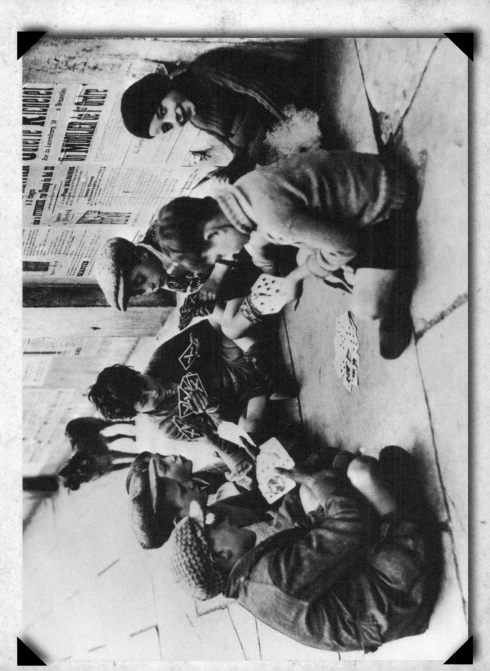

Life were simpler back then. If you wanted to play Humpty Dumpty, no-one was going to stop you.

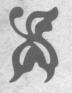

Everybody looked on the bright side. They didn't expect things to go wrong.

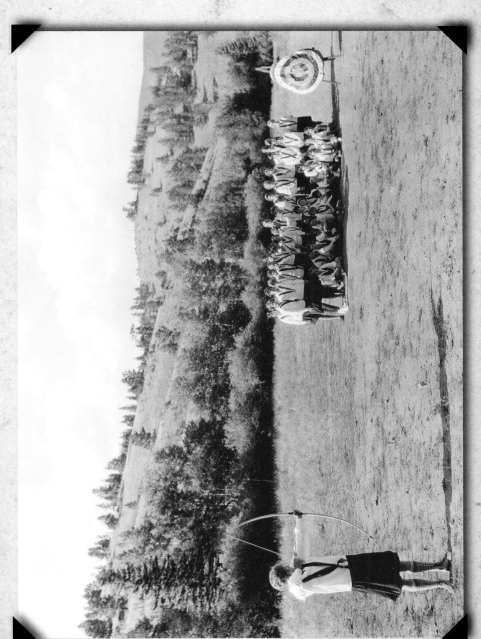

...except that time at Bridlington when the escaped alligator wasn't actually dead.

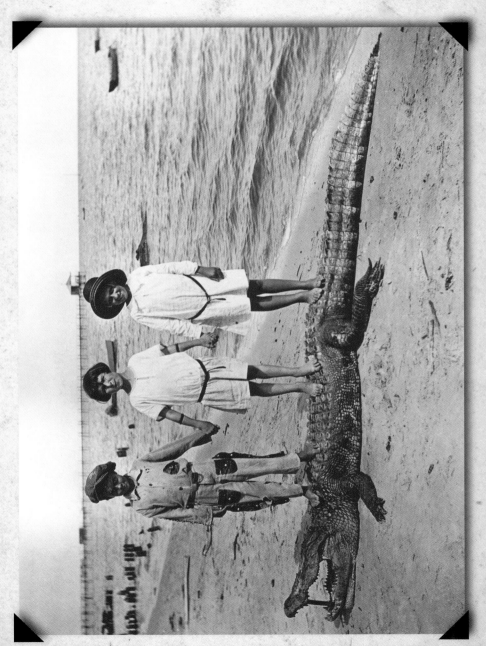

Thrill Seekers

People go on and on about risks of smoking, but my uncle Stan smoked 60 a day from the age of six and it never did him any harm. Mind you, he was knocked over by a tram when he were twenty-four.

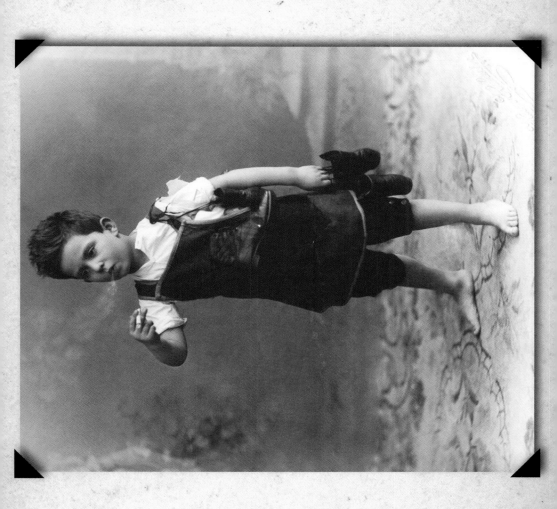

135

We didn't need Sky Plus when we had the joy of a canal.

If we overstepped the mark, we knew we'd get a bit more than a visit to the "naughty step".

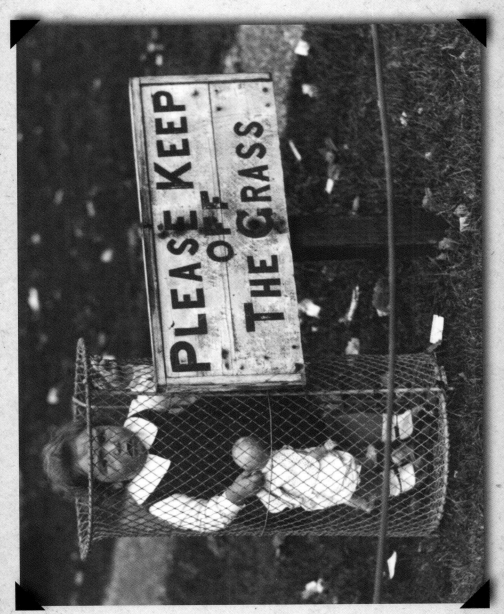

There was nowt to equal the thrill of getting all dressed up and standing on a plexiglass awning all afternoon.

139

If you were an adult back then, you could get away with acting like a complete barmpot without involving social services.

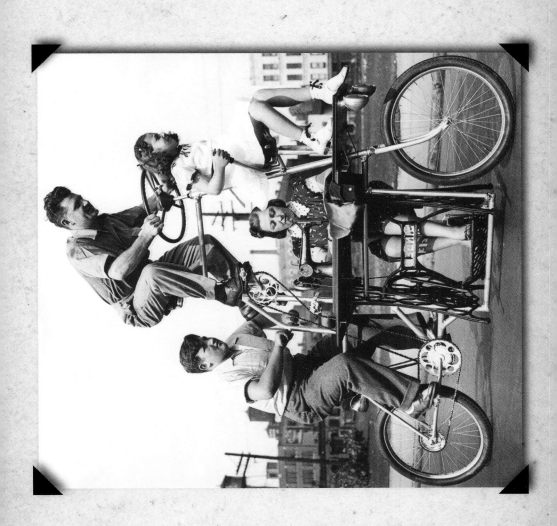

But sometimes we should have taken a bit more care. My uncle were doing around 60mph on his Velocette Torpedo when he had to slam brakes on hard.

We never found out what happened to Auntie Freda and baby, but they weren't mentioned on following year's Christmas card.

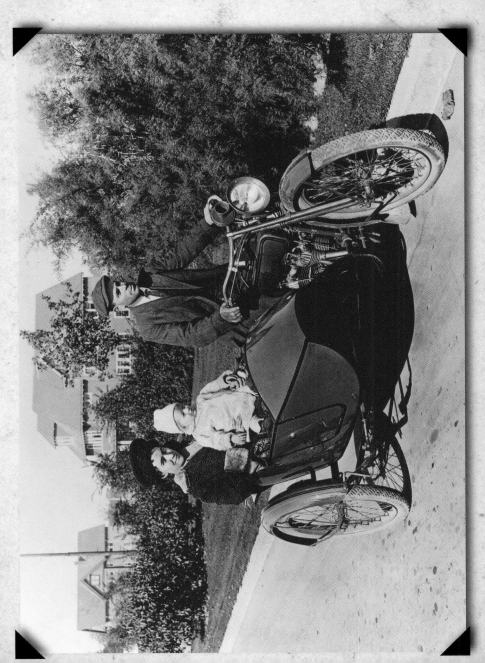

143